CREATIVE
DRAWING PROMPTS
FOR KIDS

ISBN: **1537097776**
ISBN-13: **978-1537097770**

Dog

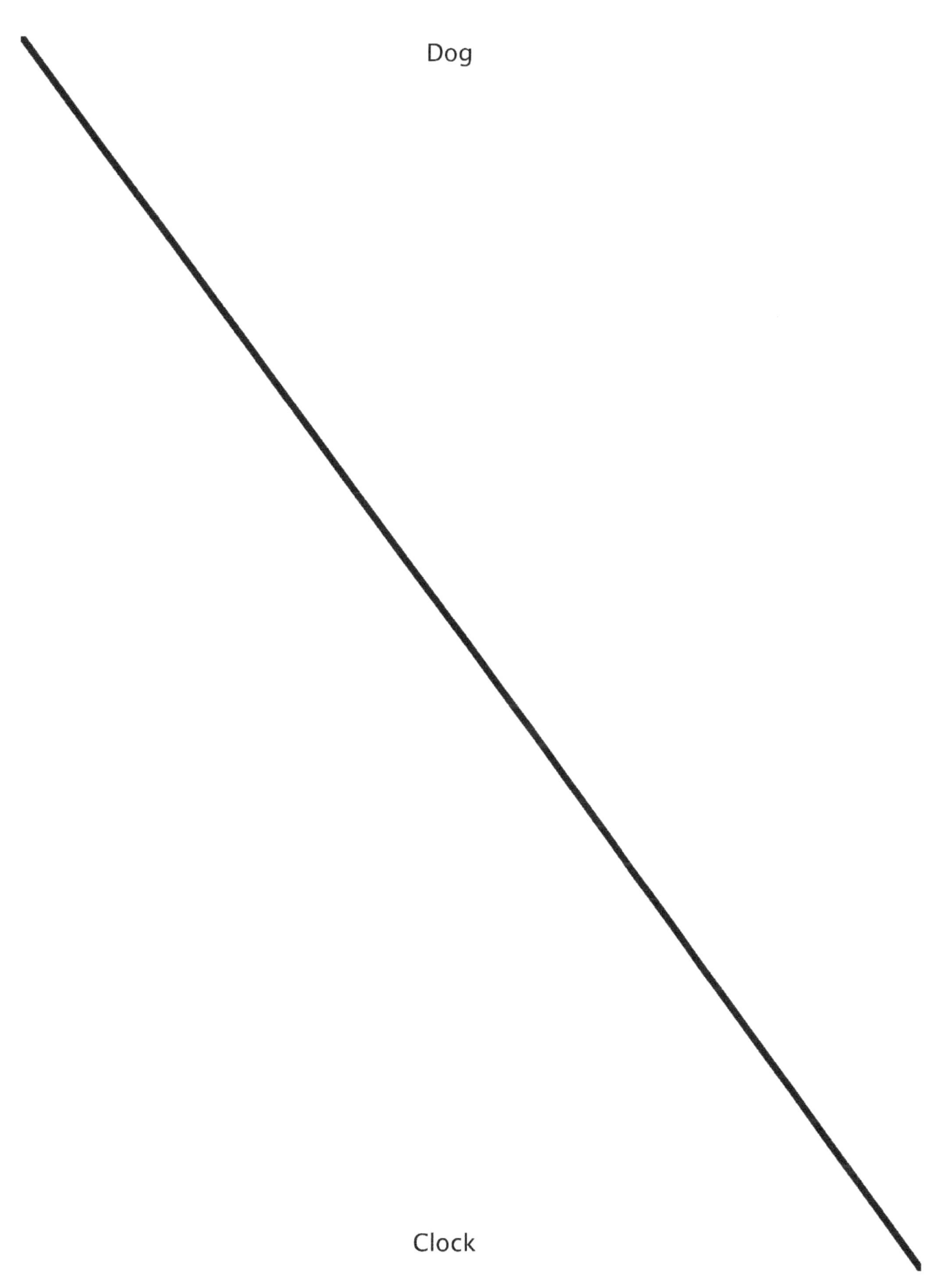

Clock

Umbrella

Octopus

Favorite Candy

Bee

Draw an animal with a superpower.

Flag of the country you're from.

Draw your family.

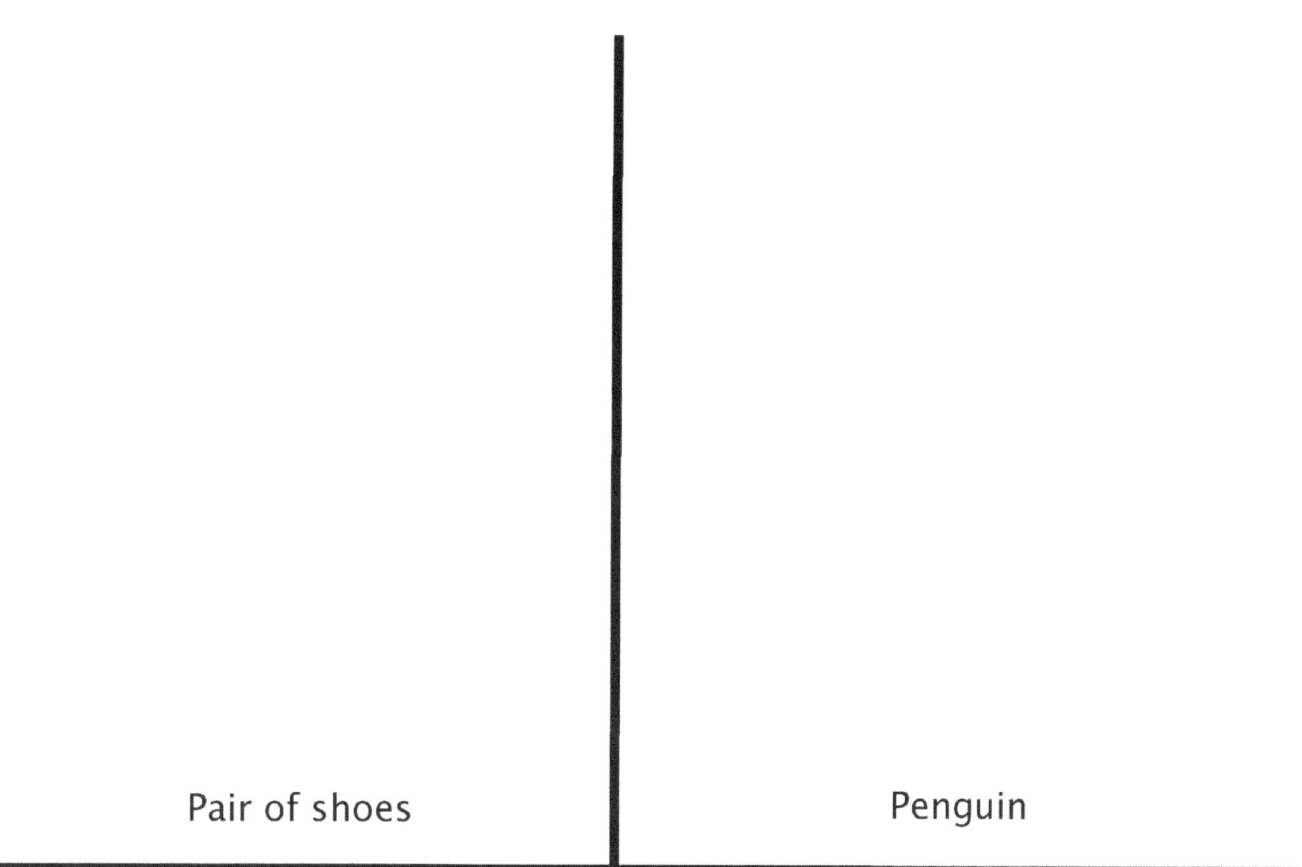

Pair of shoes

Penguin

A Bridge

Unicorn

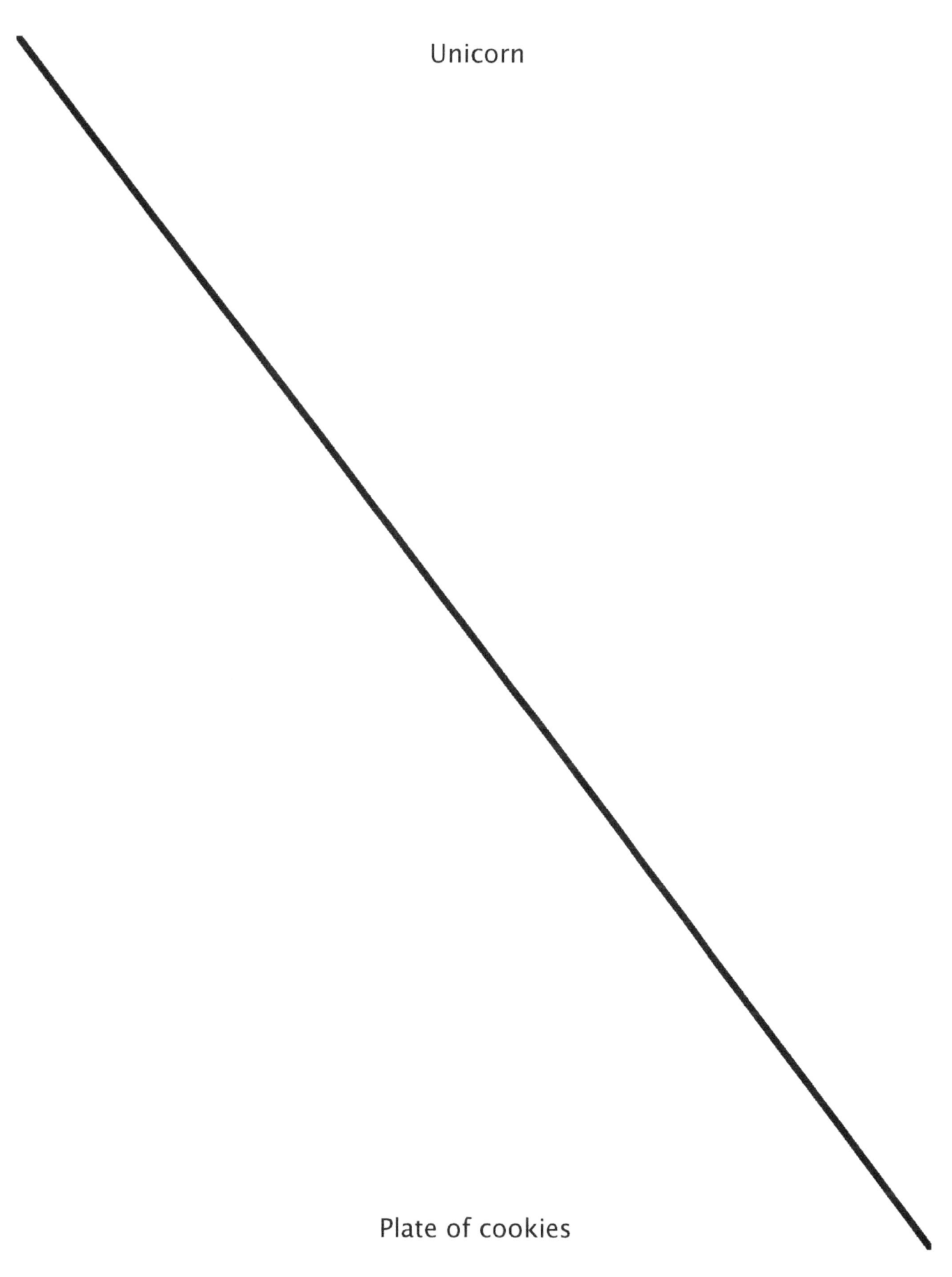

Plate of cookies

Draw a TV.

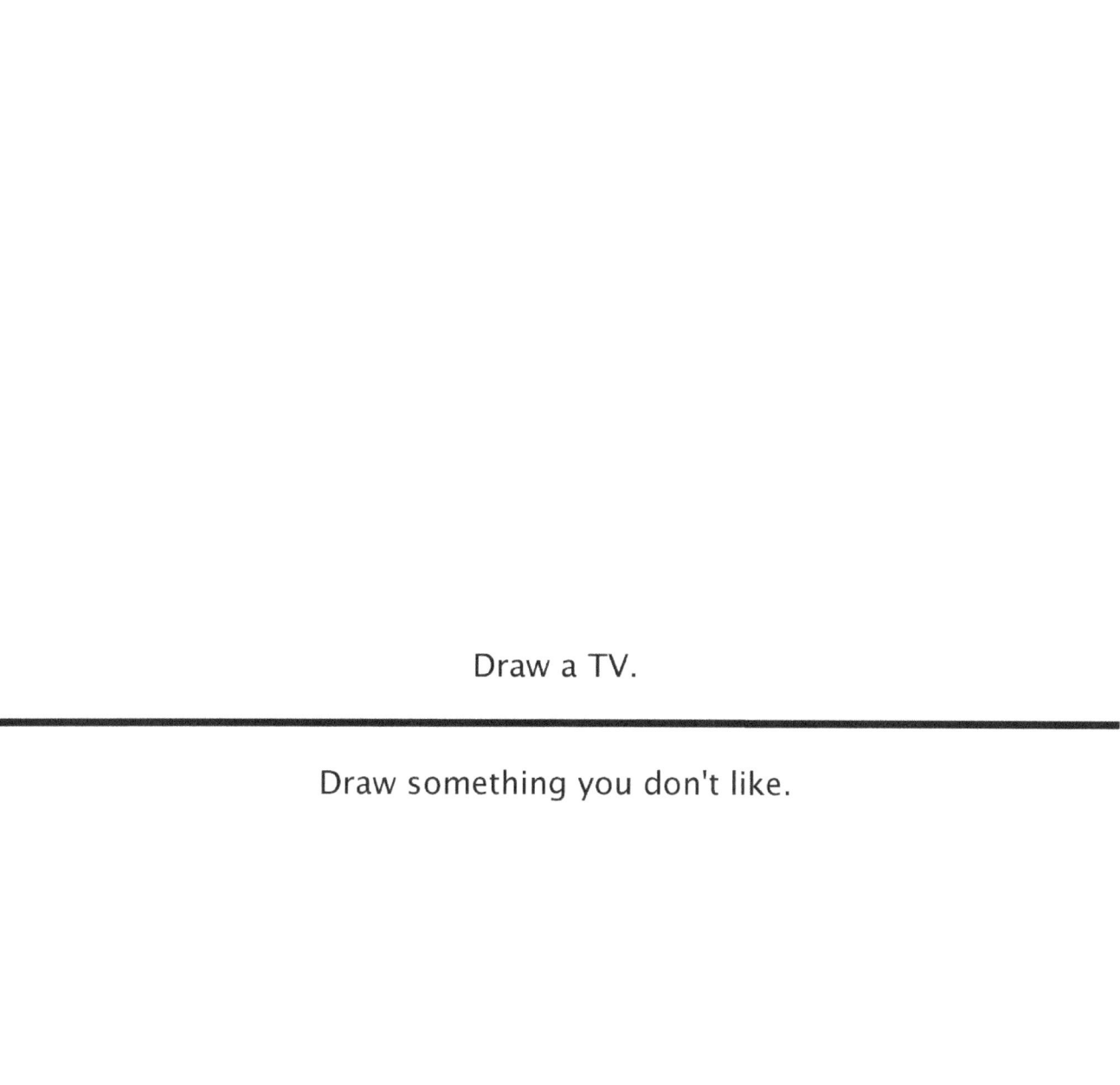

Draw something you don't like.

Rain Cloud with Rain A Bird Nest

Pair of Shoes Penguin

Think of the funniest face you have ever made. Draw it.

A Spaceship

What you do on Vacation.

Sea Shells	Koala
Bicycle	Headphones

Moon and Stars

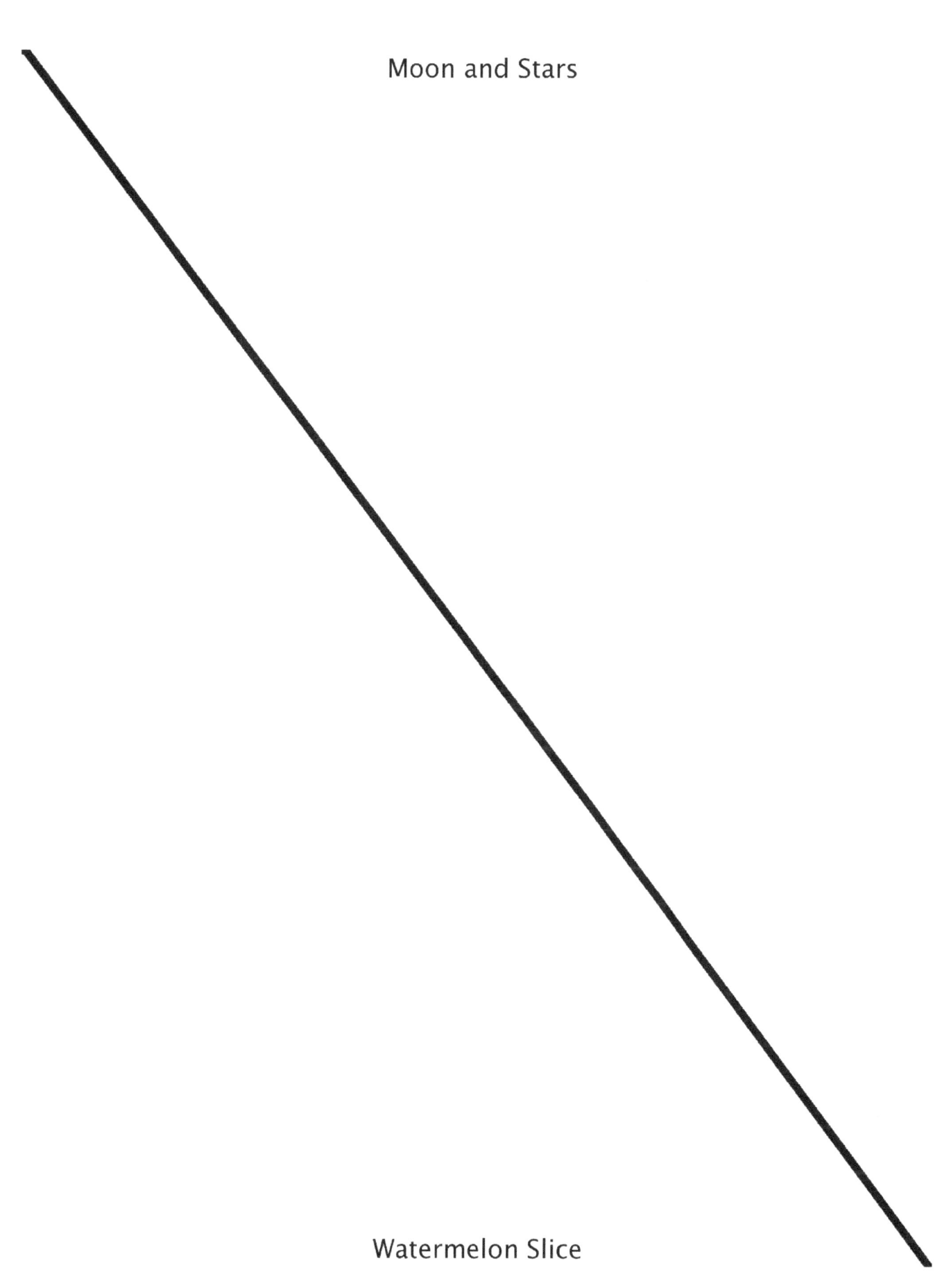

Watermelon Slice

Draw something that happened today.

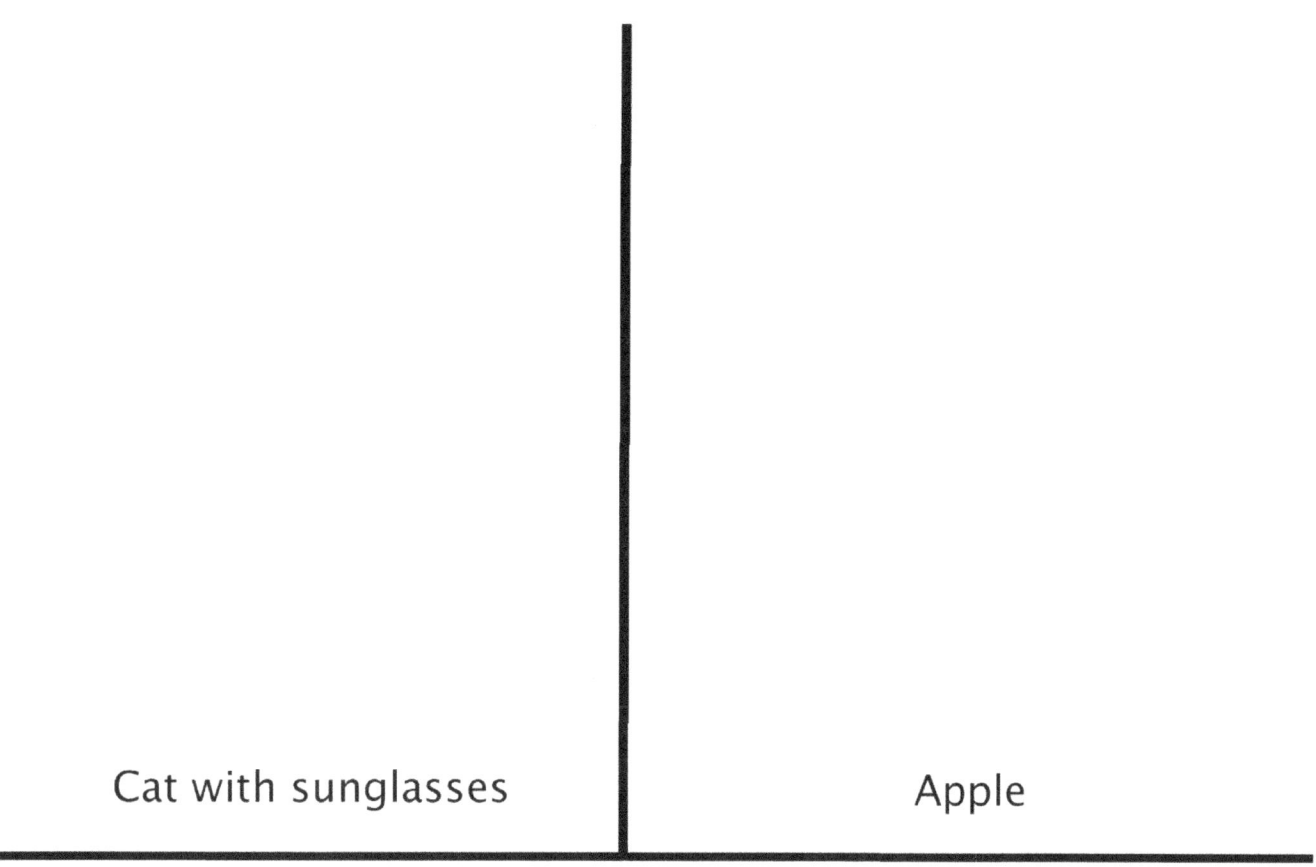

Cat with sunglasses | Apple

Draw somebody playing a sport.

Find a shadow a put your paper under it. Trace the shadow.

Butterfly

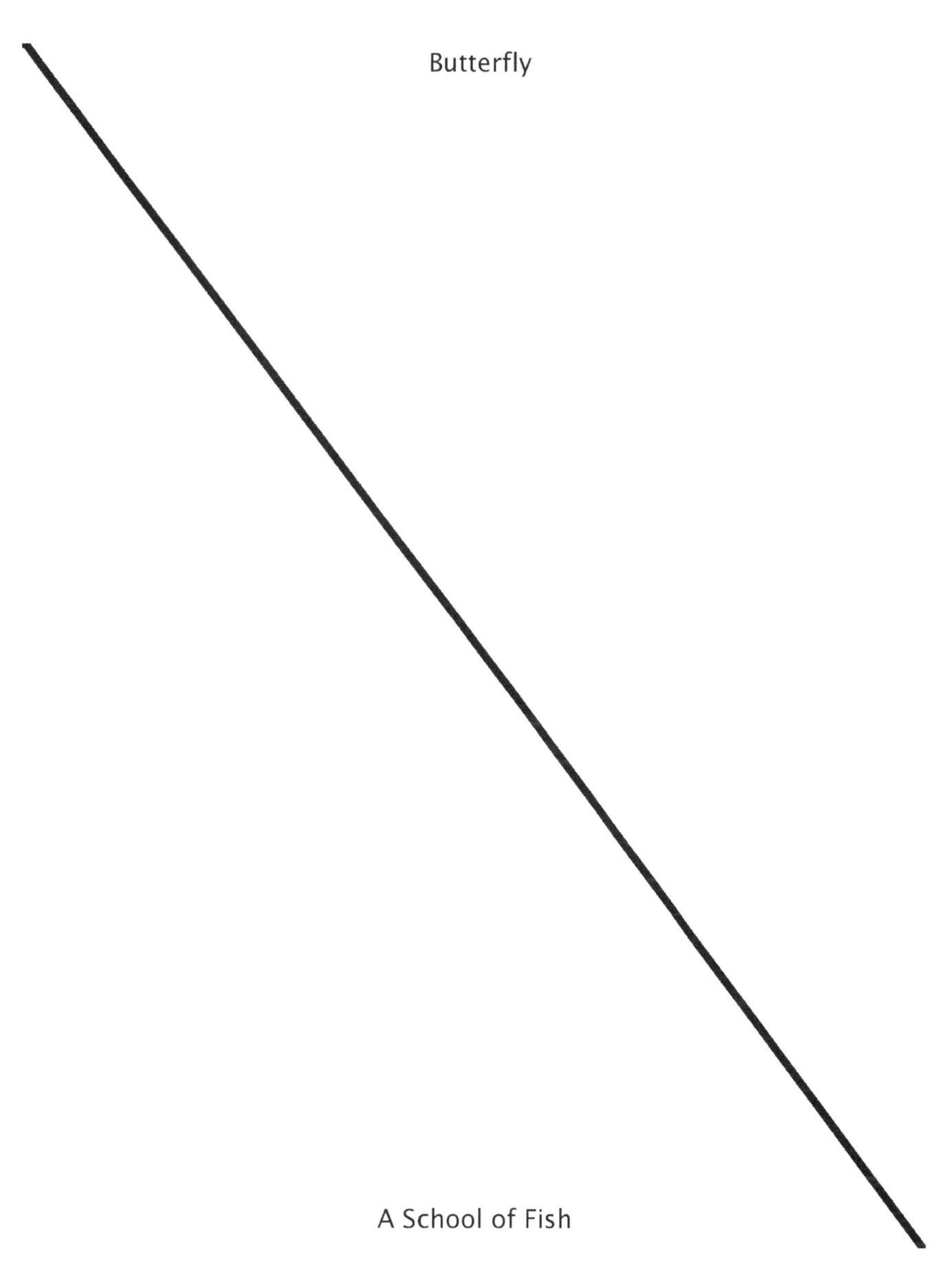

A School of Fish

Rabbit	Sail Boat
Owl	Volcano

A Monster

Draw someone going camping.

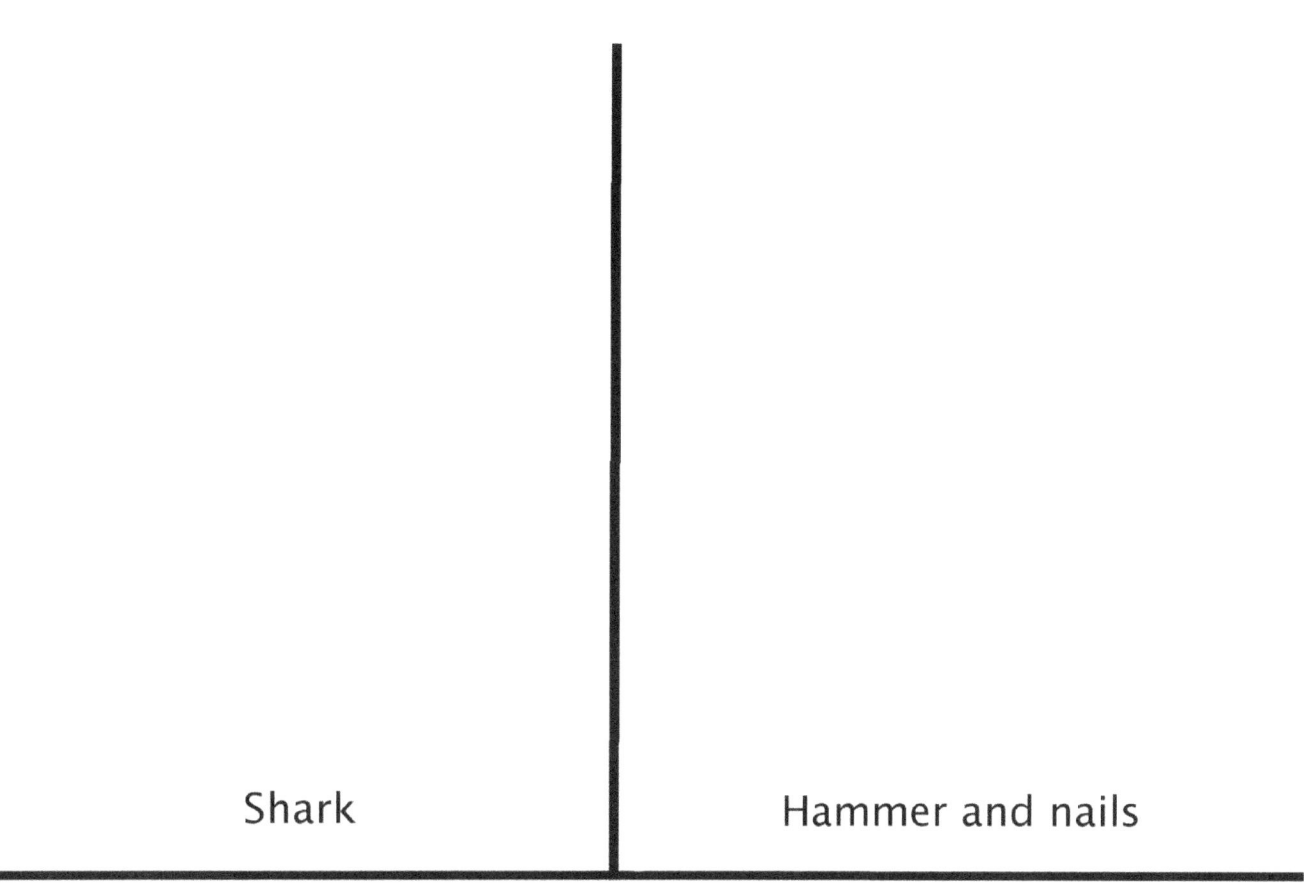

Shark Hammer and nails

Draw a scarecrow.

Draw a person with an animal face.

A watch	An insect
Pizza	A Snake

Pancakes

A Treehouse

Fireworks

Elephant

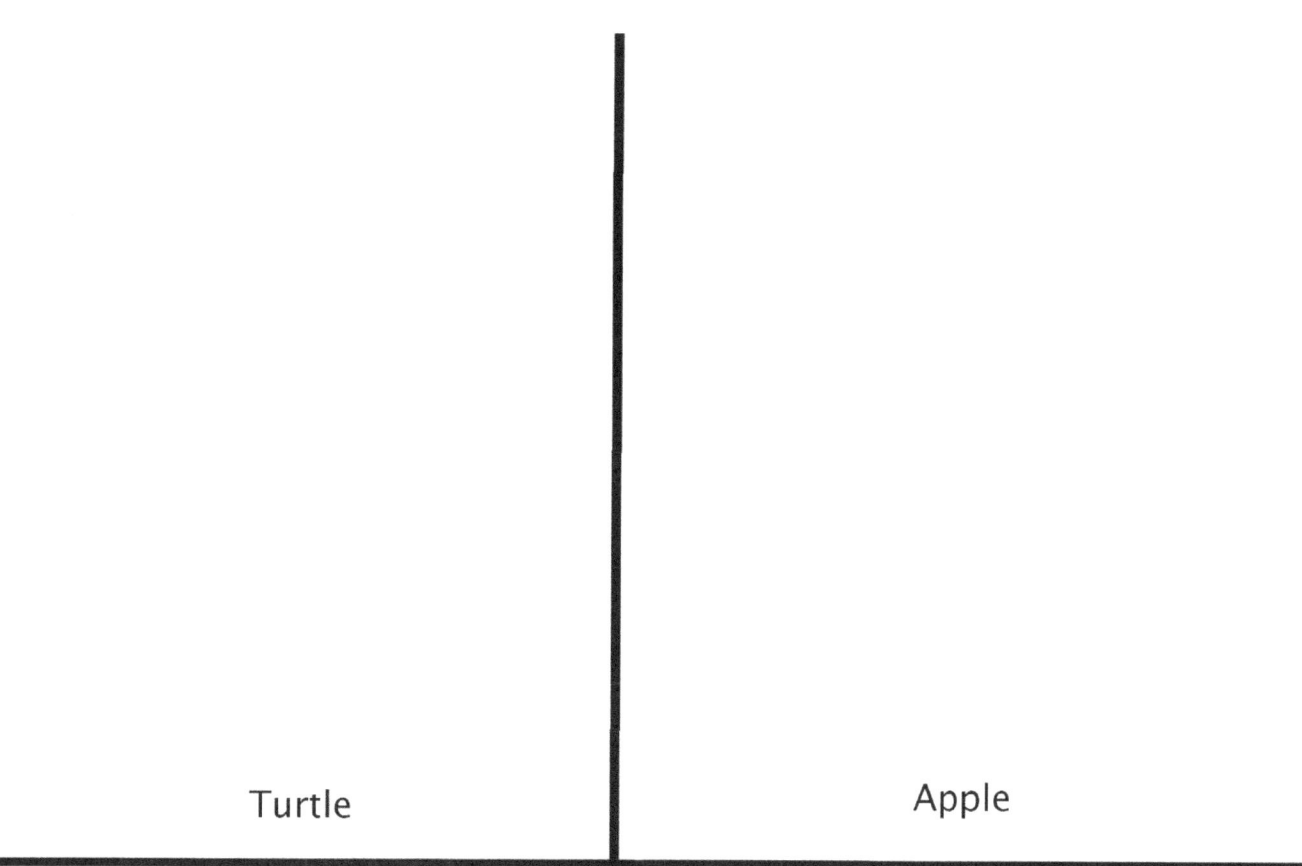

Turtle

Apple

A trophy you'd win.

Airplane

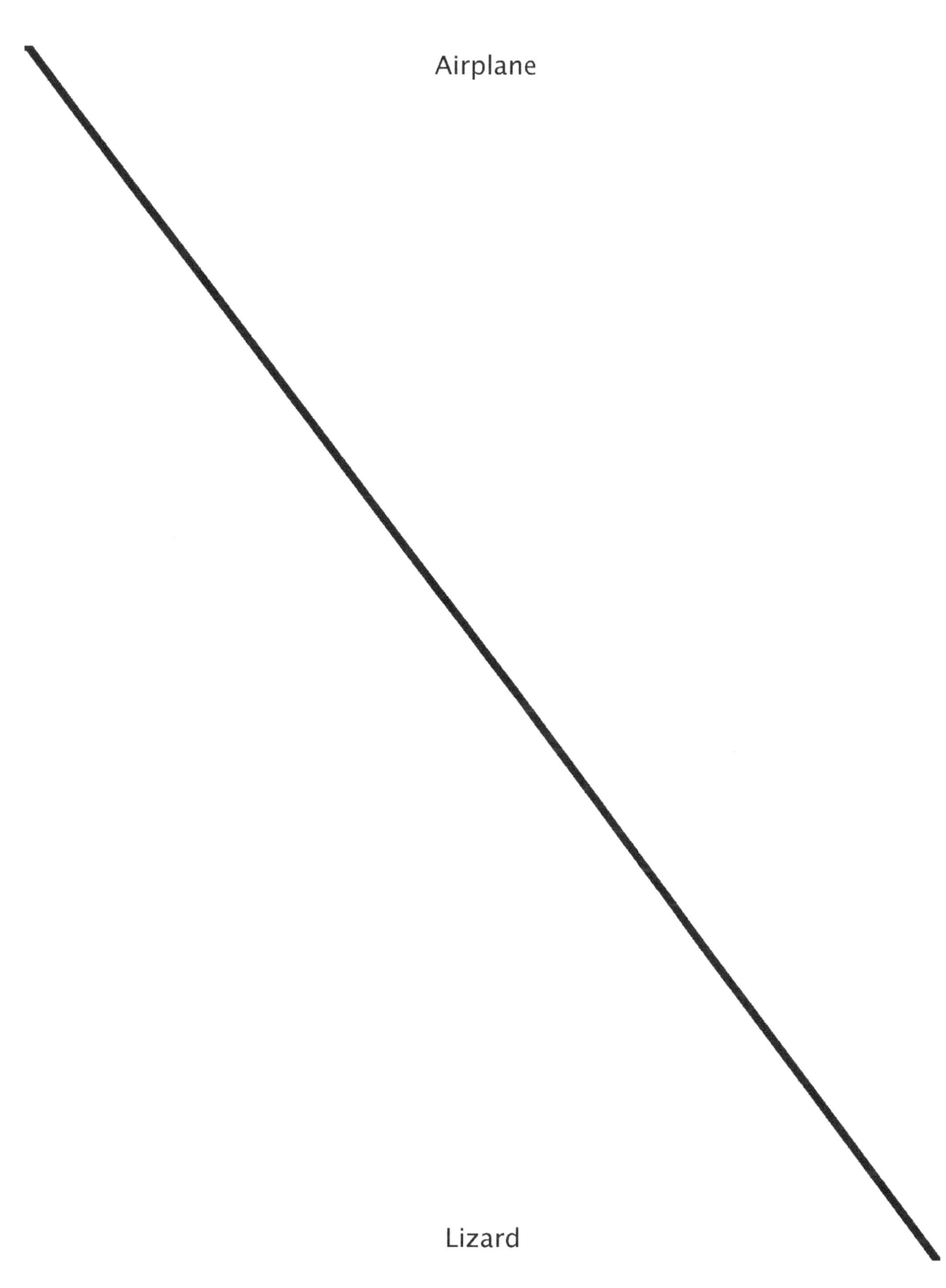

Lizard

Snow Globe		Panda
Horse		Baby

A Hamburger

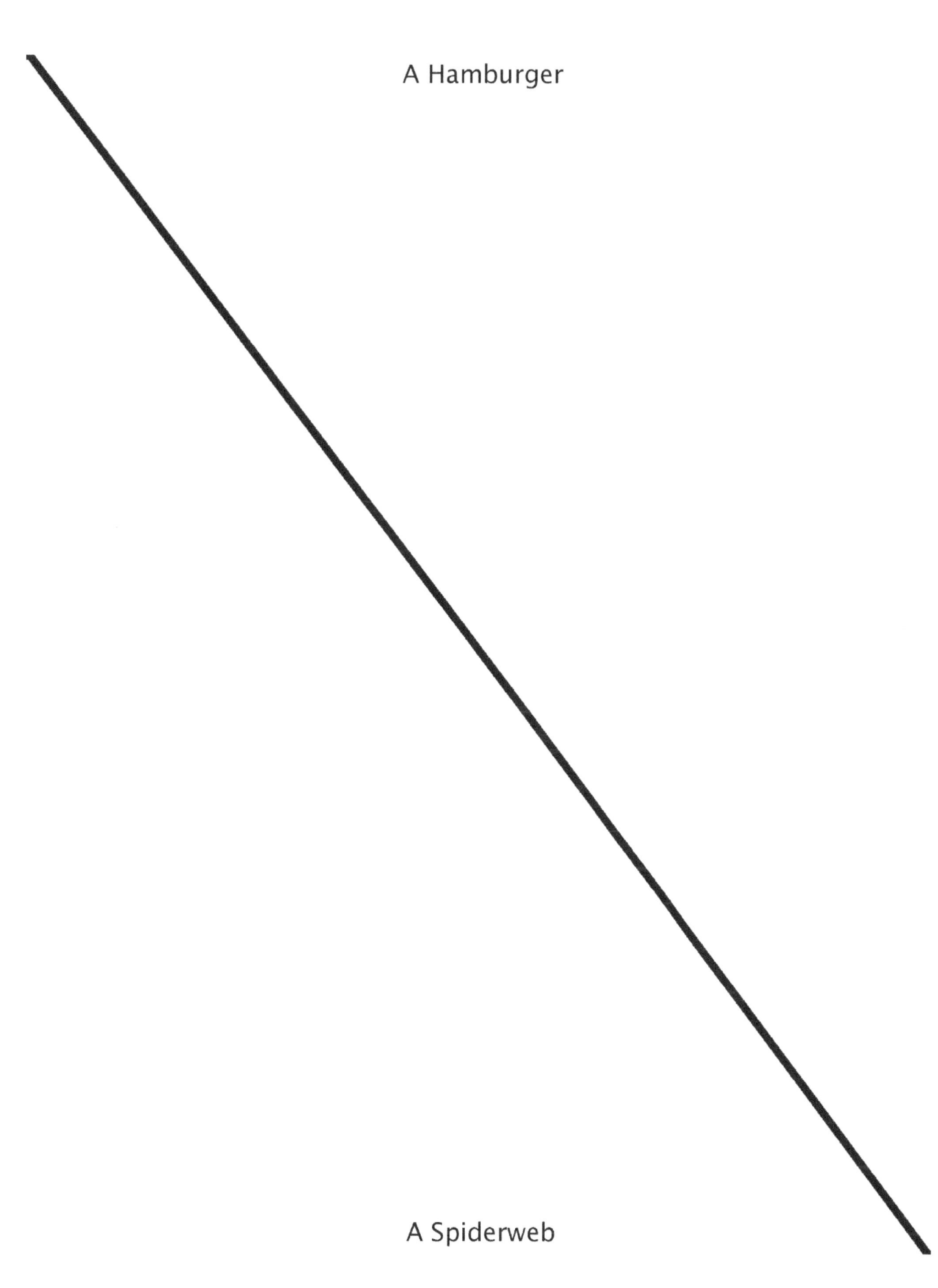

A Spiderweb

Draw your favorite Holiday.

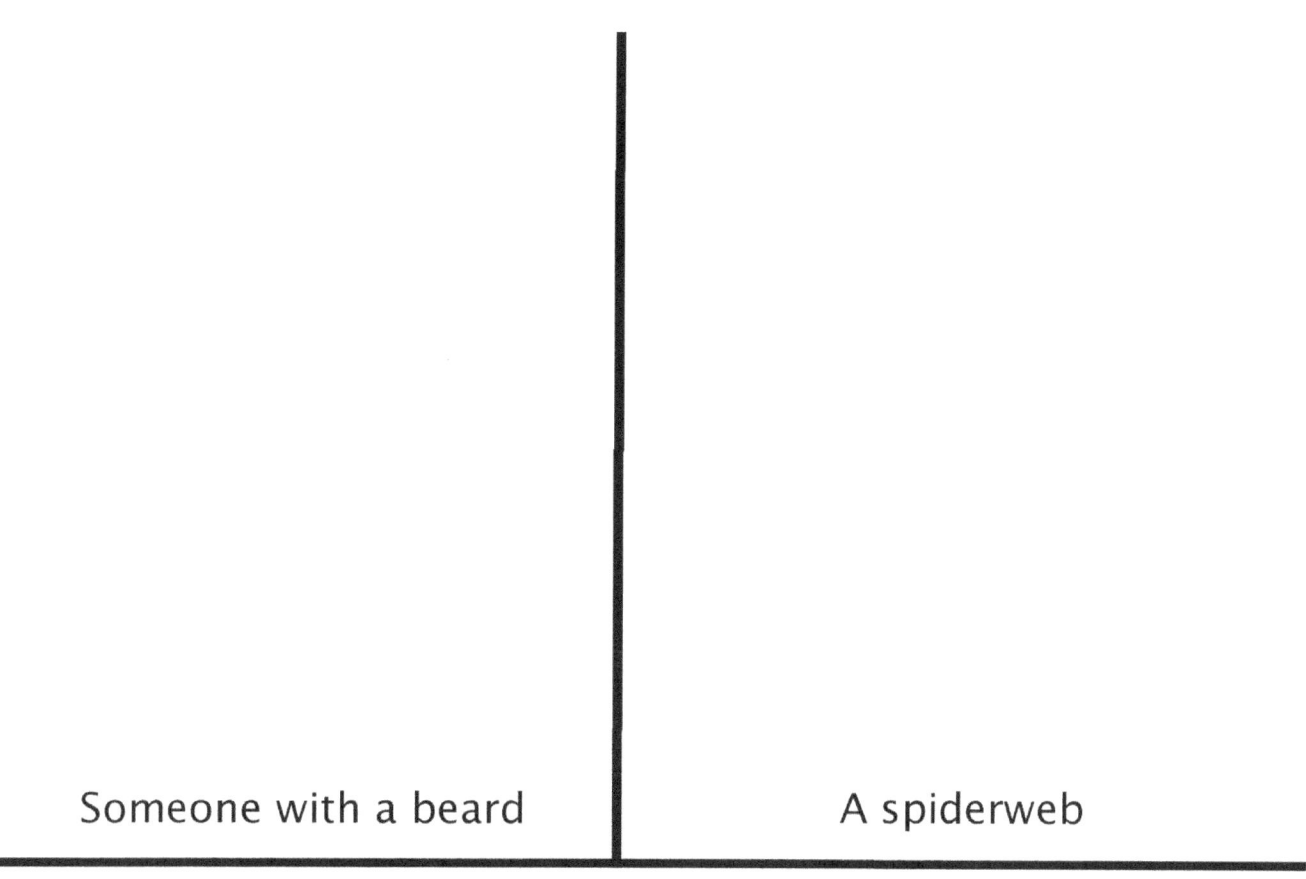

Someone with a beard

A spiderweb

A person washing a giraffe.

Airplane

Flowers made with numbers

Rat wearing a hat, on a mat, with a bat.

Birthday Cake

A stick person sitting down. | A frog with a top hat.

A silly shirt design.

Tree

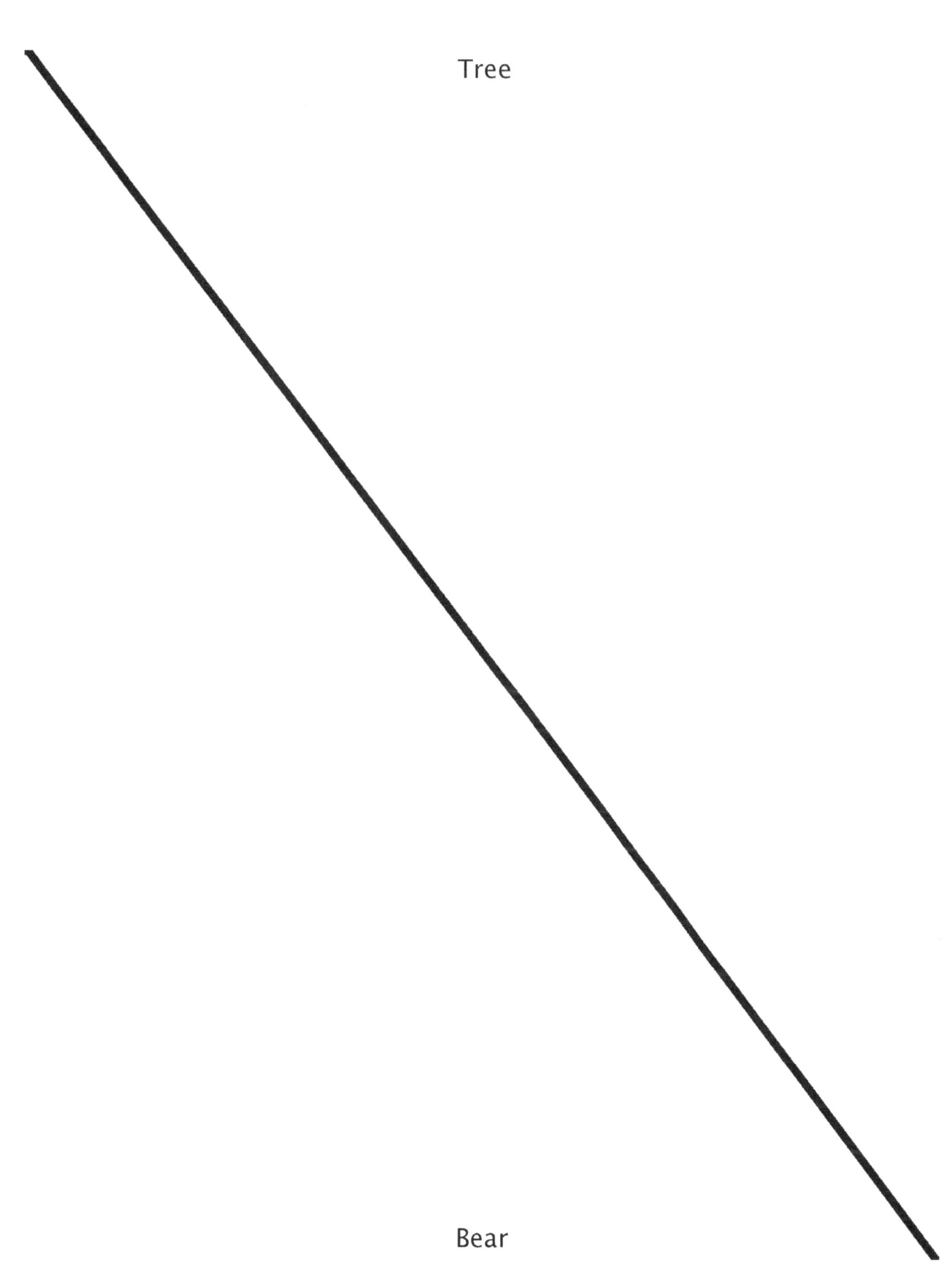

Bear

Draw yourself as a robot.

Lady Bug

Duck

Monkey doing jumping jacks

Saturn

A fork and spoon

A plate of spaghetti

A kangaroo with muscles.

Two Kids High-Fiving

Hot Air Balloon

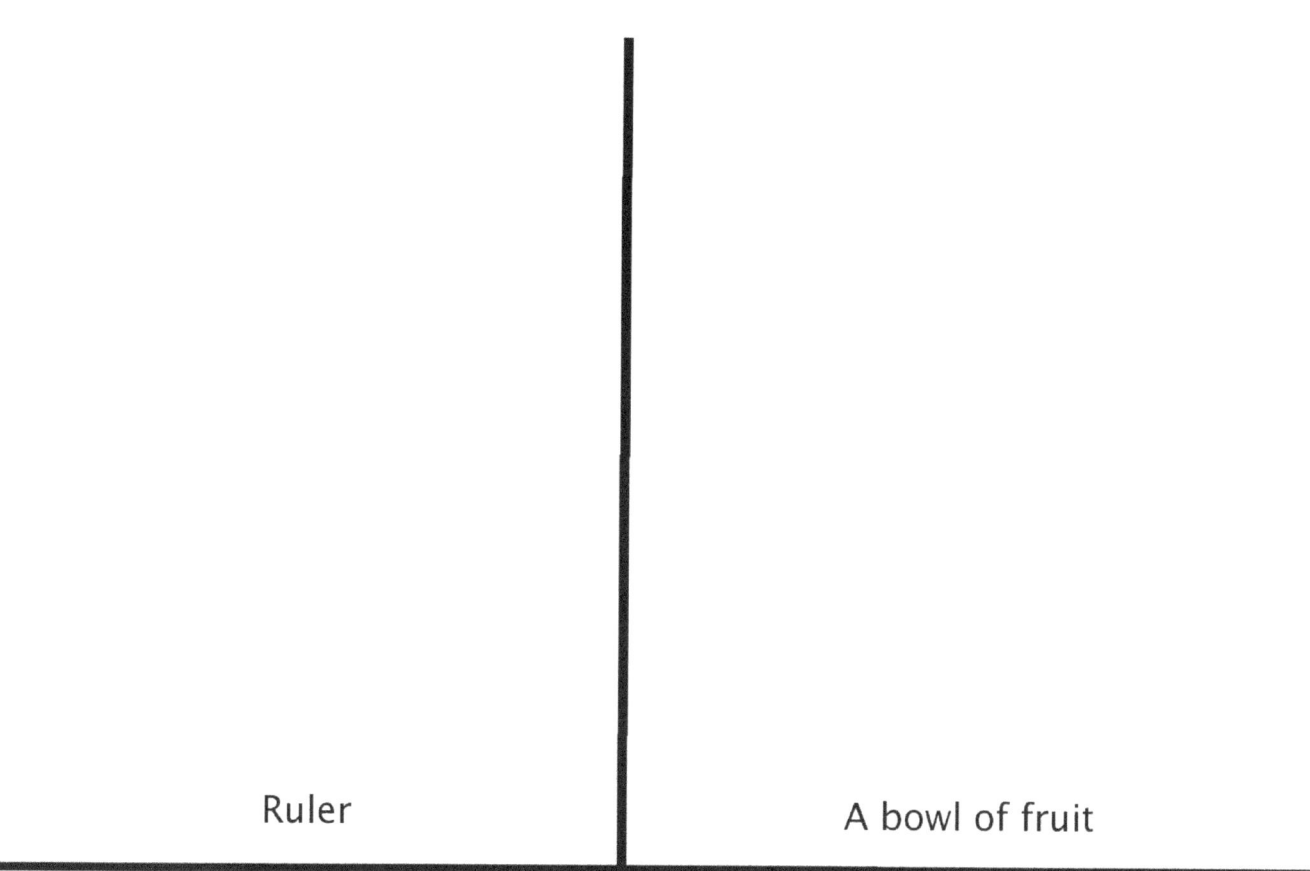

Ruler

A bowl of fruit

A lamb painting a picture.

Banana Peel

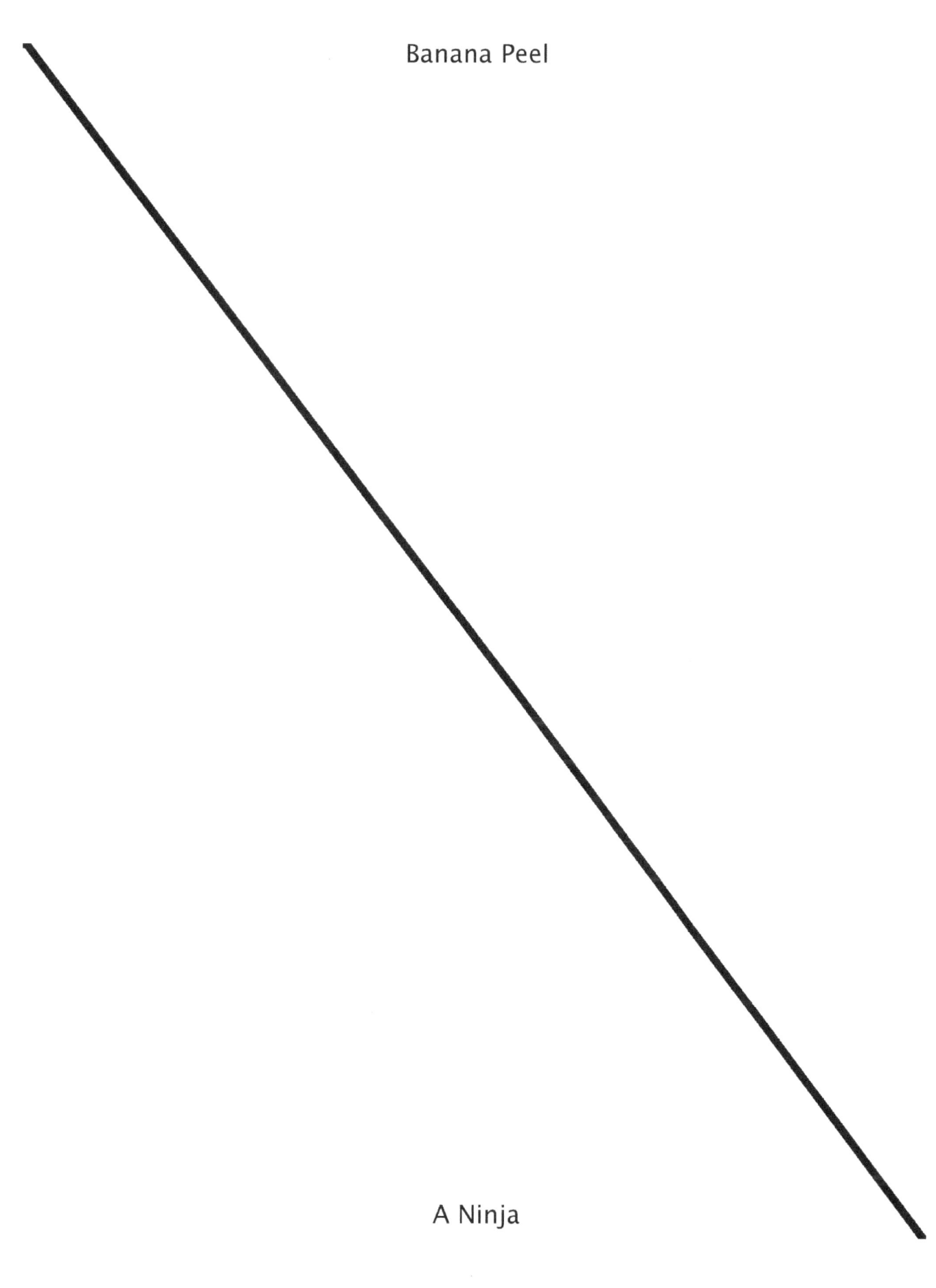

A Ninja

Fish Bowl with fish.

Zebra

Draw what you see through a window.

Something that makes you happy.

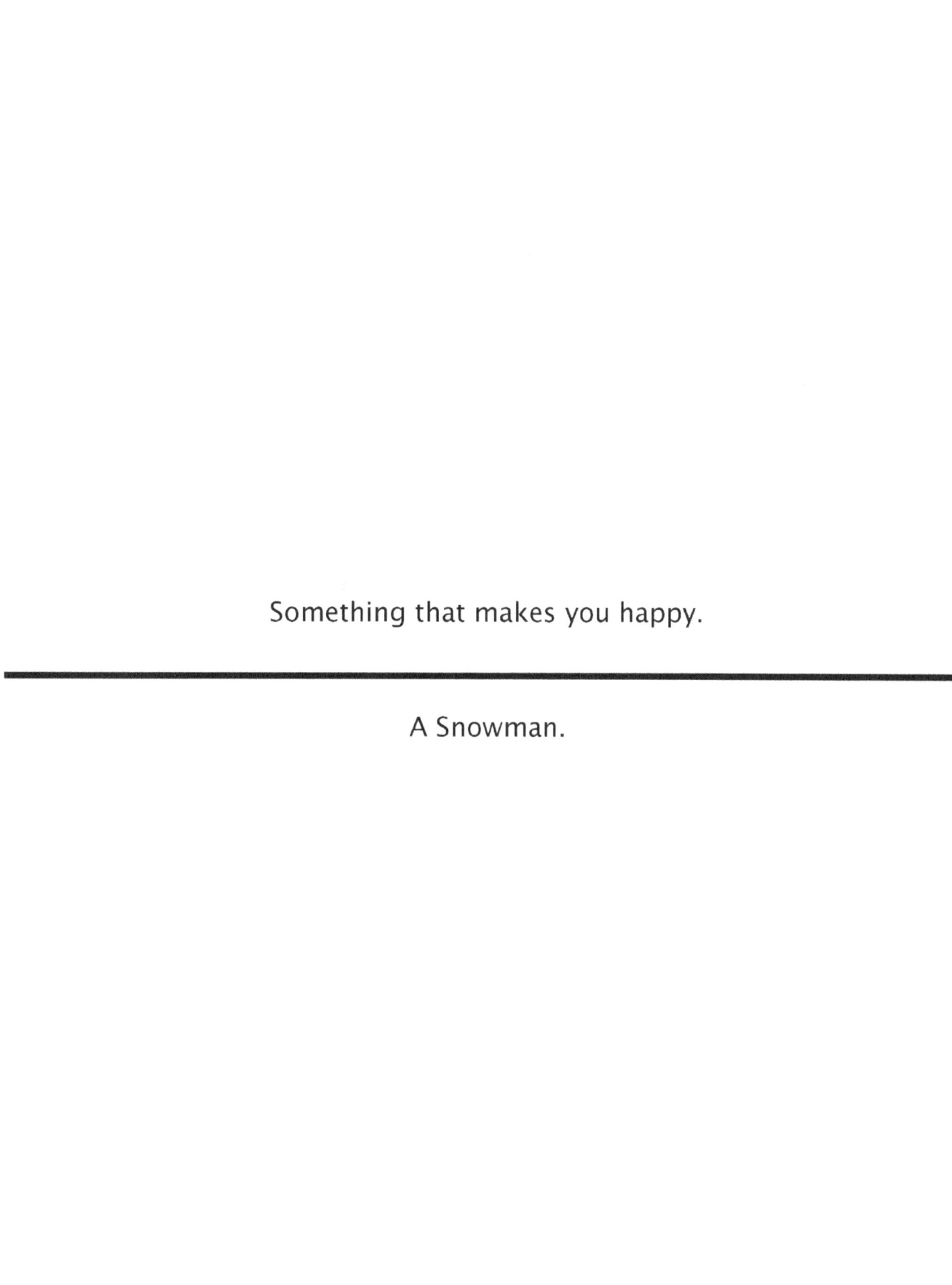

A Snowman.

Draw a dinosaur practicing Kung Fu.

A Bridge

Treasure Chest

Draw something in the ocean.

A Fireman

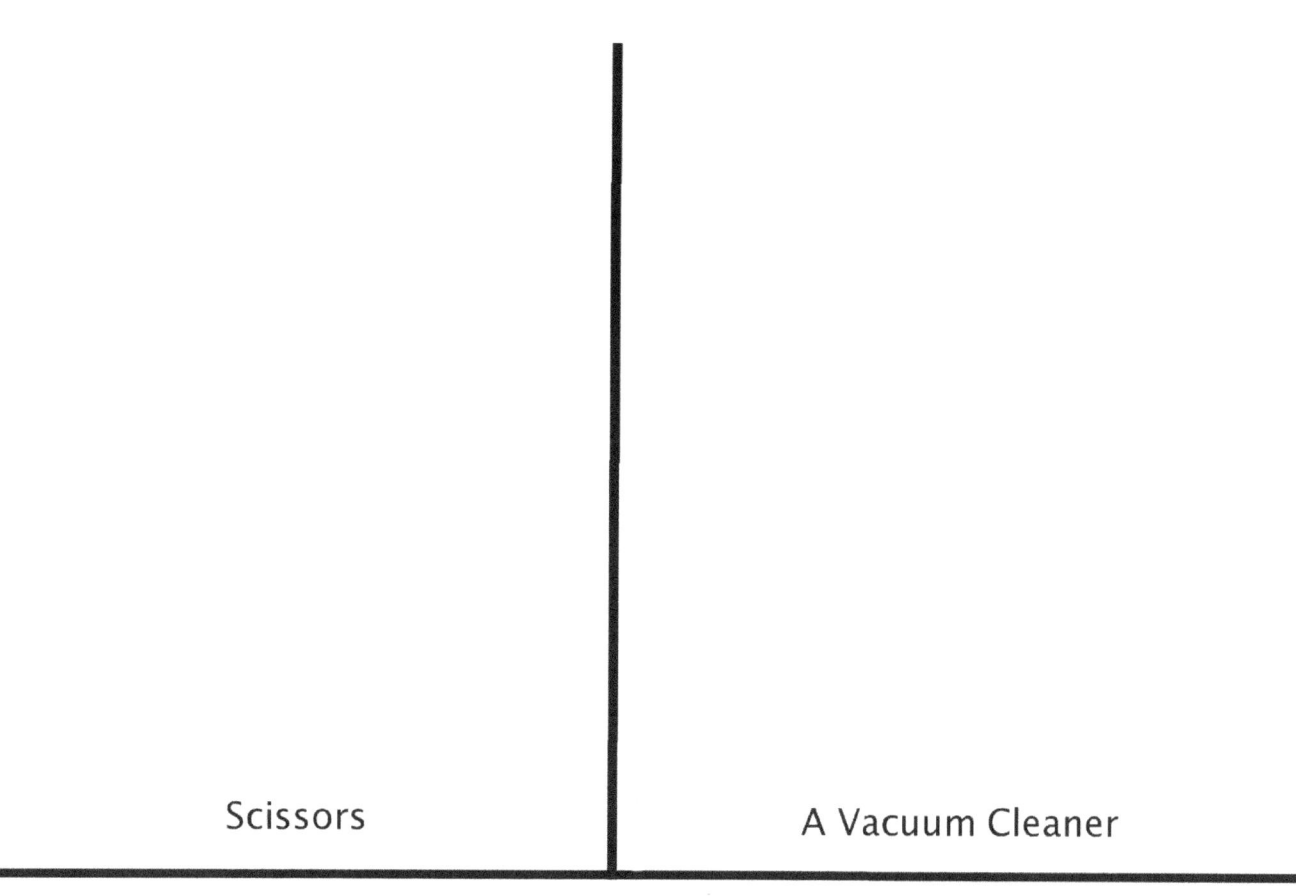

Scissors | A Vacuum Cleaner

Draw as many different shapes as you can.

School Bus

Mountains

Draw something that's on the table.

Draw something that's red.

A Skateboard

Kangaroo

You are an inventor. Draw your new invention.

Dolphin jumping through a hoop.

A Dragon

Draw your favorite food.

Draw something round.

Draw what you ate for breakfast.

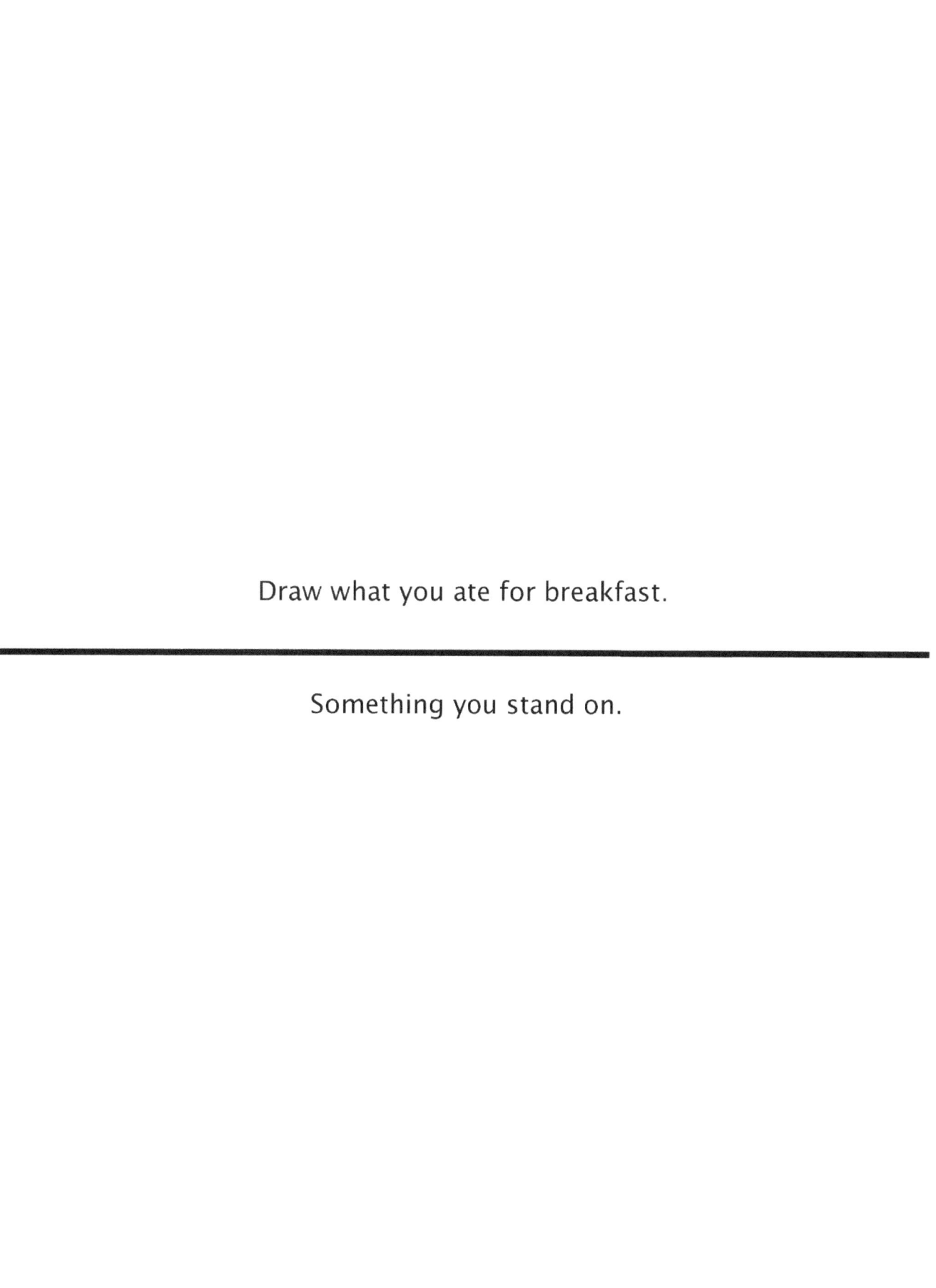

Something you stand on.

Draw the clothes you're wearing now.

What occupation you'd have when you're an adult.

Draw something that you carry in your pocket.

Draw something that makes you laugh.

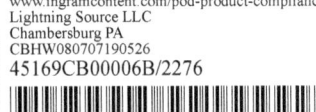